e s to r
is town any
it's all so
blown I ca
r think str

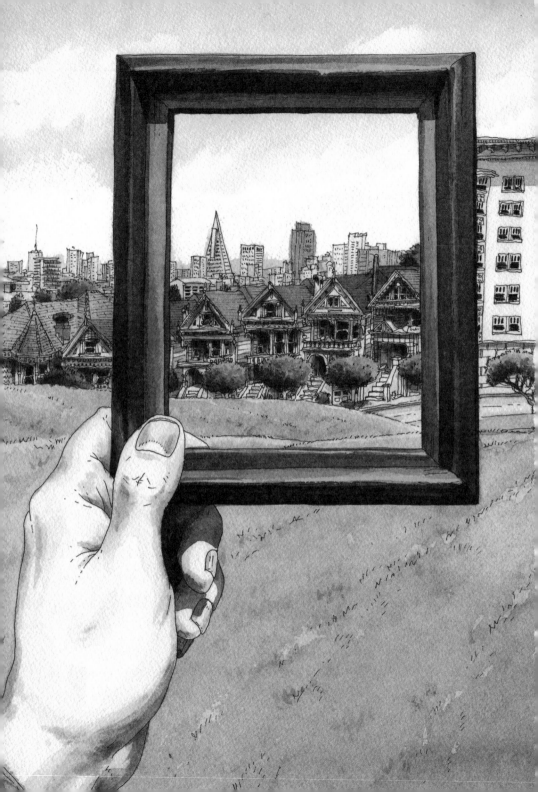

0

IMAGINE YOU'RE ON an airplane. It's a long flight. International, crossing an ocean. It can be to anywhere, you decide. Pick someplace good. A place you love, or have always dreamed of seeing. You've already boarded, stowed your luggage, fastened your seatbelt, and suffered the safety video. The plane has taken off and the cabin lights have dimmed. Maybe you've read a few pages of a novel, or maybe you've dialed up a movie, but either way, you've settled in and fallen asleep.

Now everything is shaking. You open your eyes to see a stewardess with her hand on your shoulder. "Excuse me," she is saying. Her eyes are intense and hard.

"Is there a problem?" you ask. Groggy, confused, you lurch forward and look around. Rows of your fellow passengers are sitting peacefully. Most with blankets tucked up to their chins. In the aisle there appears to be an especially long line for the restrooms, but that doesn't seem worthy of concern.

"I said excuse me!" the stewardess says again, and

this time she grabs a fistful of your shirt. "You need
to get up."

"What?" you ask. "Why?" But she has already unbuckled
your seat belt and is pulling you to your feet. She is
remarkably strong.

"You need to go," the stewardess says, and as she tugs
you into the aisle a new passenger slides into your
seat. Without a word this person kicks off their shoes,
reaches into the seatback compartment, takes out the
book you had started reading, and settles in.

This makes you angry but when you turn to give
the stewardess a piece of your mind she shoves you
hard and you go stumbling down the aisle. You try to
regroup but she keeps shoving you until you're at the
front of the plane where another stewardess is turning
the handle to the door. You want to scream, Wait! But
then the door opens and a blast of cold air rushes in.
Shockingly, you find you can still breathe, and even
more shockingly, no one else on the plane seems to
care. The guy sitting right there in the emergency exit
row, he just pulls his blanket a little tighter and slides
the courtesy sleeping mask over his eyes.

"Please," the stewardess says. "Don't make this any harder than it needs to be." And she motions to the open door. Outside you see only blackness. Maybe some white-grey clouds far below, but otherwise, nothing. The stewardess, frustrated by your unwillingness to move, rolls her eyes, as if every second of your continued unwanted presence is an egregious and personally offensive violation of not just man's law, but God's as well. Seeing that you're one of those entitled types who won't go without a reason, though, she takes a deep breath and says, "The market has changed. We can now charge five times what you're paying for your seat. Which means you have to get out."

"But it's mid-flight," you say. "And I've already paid for my ticket."

"You were only renting," she says. "And we own. This is just the way things are." And she pushes you out the door.

Book design by Alvaro Villanueva
Printed in China

ACKNOWLEDGMENTS

Portions of this book originally appeared in the *San Francisco Chronicle*, on SFGate.com, BrokeAssStuart.com, and theRumpus. net, between June 2015 and December 2015.

Thanks to my wife Joen Madonna, and to Kate and Scott Murphy, who read countless drafts of these chapters, often late at night, on short notice, hours before going to print.

Thanks also to Elaine Katzenberger, Colleen Newvine Tebeau, and to all the readers of All Over Coffee, who enabled a dream to come true.

Library of Congress Cataloging-in-Publication Data (on file)

Visit our website: www.citylights.com

City Lights Books are published at the City Lights Bookstore, 261 Columbus Avenue, San Francisco, CA 94133

On to
the Next Dream

PAUL MADONNA

City Lights Books | San Francisco

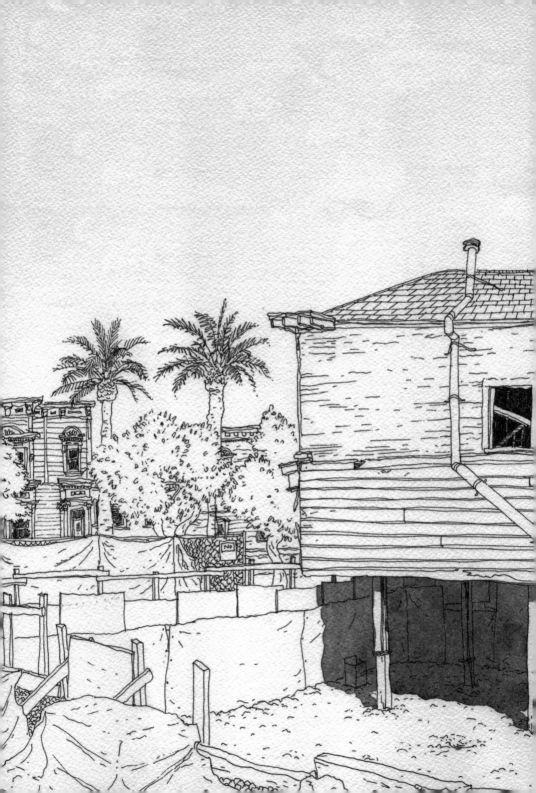

1

I WAS SITTING in a café, because that's something
I like to do, eating an egg sandwich and reading a noir
detective novel on my iPad. It was a Tuesday, mid-
afternoon, and having just gotten a haircut I was looking
about as respectable as I can get. A woman sat down at
the table to my left and began muttering to herself. Out
of the corner of my eye I could see her glancing my way,
and when I made the mistake of turning my head she
barked, "Usurper."

I looked at her and blinked.

"You think you can just waltz into this city and do
whatever you want," she said. She was about my age,
early to mid-forties, and looked like someone I might
know. "But just because you type a few ones and zeros
into a computer doesn't mean you have the right to jack
up my rent and throw me onto the street. Tell me, what
do you think this place will be like after you've driven
out all the people who make it great?"

To my right I heard laughing and turned to see two

young guys in gym shorts, hoodies, and flip-flops watching us. When I met their eyes they buried their faces into their phones.

I tried to return to my buddy Philip Marlowe. He had a murder to solve and had just gotten sapped by a crooked cop. But with eye-daggers of self-righteousness shooting at me from one side and sniggers of entitlement from the other, I couldn't focus, so I got my coffee to go and left.

Outside, a pair of men dressed in identical picnic-table plaid shirts were pointing at the building. "Let's just tear it down," one said. "Then we can do whatever we want."

I had to step into the gutter to get around them. A car alarm screamed so I dove back onto the sidewalk only to have a toothless man ram me with a shopping cart and tell me I'm in the way.

2

I RETURNED HOME to find an eviction notice taped to my door. I couldn't believe it. A week earlier the landlord had told me she was raising the rent beyond the legal limit and I'd attempted to negotiate, but to respond with an eviction? I'd been in the place ten years and never once asked for anything. I'd attended her father's funeral. It was absurd.

I lifted my key to the lock but found my hand shaking so wildly that I looked around in embarrassment. What was I going to do? Losing my home was bad enough, but this was my studio too. My livelihood. Without it how was I going to— And that's when I noticed that my neighbor was having an open house.

There was a line out the door but I managed to squeeze inside. "Asking price is one million," I heard the real estate agent call out. She was standing on the kitchen counter, strapped into a square-shouldered business suit, scanning the crowd with eyes like an airport x-ray machine.

"But of course it will go for hundreds of thousands

more," a man said, pushing me aside with a baby stroller.

"Obviously," said the agent. "A million is just how much it takes for me to treat you like you actually exist."

"Well then here I am," the man said, throwing his arms wide then gesturing grandly to the stroller as if he were presenting a newborn king. That's when I saw that the carriage was filled not with a baby, but with bundles of crisp hundred-dollar bills.

Cupping my hands to my mouth I asked, "How many bedrooms?" And when a shrill "Ha!" erupted from across the room I turned to see a bird-legged woman in a baseball cap and extra-tight workout clothes shaking her head at me.

"It's not the apartment that's for sale," she said, as if I were a potted plant that had miraculously learned to speak. "We're here to bid on that—" and like a Suburban Samurai brandishing her sword, she whipped a yoga mat from over her shoulder and pointed to a cardboard box in the corner.

Instantly the stroller guy darted over and hopped

inside the box. "It's perfect!" he squealed, squatting down like a fat housecat squeezing into a coffee cup. "And now it's all mine, mine, mine!"

3

I LEFT THE OPEN house feeling dizzy—I mean, over
a million dollars for a box? How was I supposed to
afford that? Let alone live in something so small?

I had to stop to catch my balance. As I leaned against
the building a pregnant woman burst out the door.

"God dammit!" she was yelling. I'd seen her inside.
With hopeful eyes she and a young man had been
licking the real estate agent's pointy shoes. Now she
was waving her arms and spitting fire. "I thought
these were supposed to be the baby lovers?"

The man stepped out behind her, his head down,
rifling confusedly through an over-stuffed folder of
papers. "I know, me too…"

The woman suddenly doubled over. She looked like
she was going to be sick, or maybe going into labor.
Then she reached under her shirt and tugged out
a large belly-shaped pillow, and when she stood up
straight again she was no longer pregnant.

"Crap," the guy said, slapping his hand against a sheet of paper. "These were the *dog* people. Or no. Wait …"

The woman cried out and grabbed her hair. "Eddie! Come on man! You have to stay organized! How are we ever going to get a place if we don't fit the absolute perfect mold of what the landlord is looking for?" She tossed the pillow into the street and stormed off. "Let's go. We have three other places to see in this neighborhood."

I decided to follow them. Trailing half a block behind I was led into another building, up two flights of stairs, and into an open apartment where I found at least two dozen people crowding into a circle. They all appeared to be yelling, but I couldn't hear a thing. I wiggled my finger into my ear, thinking maybe it was me. Then I heard someone say, "Go on. Go in." And I turned to see the ersatz pregnant woman from earlier, her arms crossed, smirking. Her man was behind her, eyeing me. "Go ahead," the woman said. "That is, if you think you can." And she motioned toward the crowd, who were all jumping and waving their arms like mute stock brokers at a soundless heavy metal concert.

I took a step forward but smacked into an invisible wall.

I stumbled backwards and the woman laughed. Then, like Marcel Marceau miming a routine, she ran her hand over what appeared to be a perfectly clear glass surface. "They're having a bidding war in there," she said. "Auctioning up the rental price as if this dump were the last dwelling left on earth."

I reached out and tentatively felt what I could only describe as a giant contact lens.

"It's a bubble," the woman said. "One small and ridiculous microcosm inside the already small and ridiculous bubble that is San Francisco."

4

THE MAN INTRODUCED himself as Eddie, then the
woman as Jessica, who said, "Dammit Eddie, we need
a place to live, not more friends," to which Eddie smiled
apologetically and invited me to join them for lunch.

The three of us went to a taqueria on 16th Street
because Jessica refused "to go to one of those foofy
overpriced boutiques where you have to sign up for
a mailing list just to eat." Standing in line, Eddie said,
"But man, those bubble-gum-fed, college-educated bison
burgers really are amazing." And for a moment he was
lost in bliss. Then his face contorted with confusion.
"What are oxidants anyway? And why are they so bad
that we need an army of foods to fight them?"

"What we need is for the drought to end," Jessica said.
"As soon as the fog comes back all these douchebags will
realize that it's not actually southern California weather
up here after all, and they'll leave."

"What we need is an earthquake," Eddie said. And both
Jessica and I looked at him. "What? Just a medium-size

one. Not bad enough to hurt anybody, but big enough to scare people away. Then the housing market will settle itself down real fast."

Jessica nodded. She was impressed.

We all ordered burritos and sat down and when I opened my mouth to take a bite, Jessica grabbed my burrito out of my hand and replaced it with hers.

"What?" she said to Eddie. "He carried all three of them over here. I had to make sure."

"Paul wouldn't poison our food," Eddie said. But then he hesitated to bite into his own. And so I took one bite from each of the three burritos to prove I wasn't trying to slip them a mickey in order to gain an advantage in apartment hunting.

"We're not even looking for the same thing," I added, to doubly reassure them.

"I don't see how you can think you deserve a two-bedroom anyway," Jessica said. "Not when you're only one person and Ed and I are willing to live in a closet as long as it has a toilet."

"Because, I don't just need a place to live, I need a place to work. Most people have their work spaces provided for them. Me, I have to provide my own. This eviction is pulling two rugs out from under me."

"This city," Jessica said. "It's become toothpaste." And in response to my confused expression she gestured to the room and said it louder, "Toothpaste?"

Eddie put his hand over his mouth. "New and improved whitening formula."

"San Francisco is being overrun," she said.

"But it's always been overrun," Eddie said.

"Not like this." And a bite must have tasted off, because in mid-chew she once again snatched my partially eaten burrito from me and swapped it with hers.

"Yes," Eddie said. "*Exactly* like this. Back in the Gold Rush days people would set up sawhorses in their parlors, lay a few planks across, and rent them out as beds for exorbitant prices. They'd charge extra for a blanket, and as soon as the renter fell asleep, they'd slip it off and sell it to the next sucker."

"Yeah, and back then people also used to shoot each other in the streets."

"Which, technically, they still—"

"Jesus Eddie! How can you even attempt to justify this? We're being run out, man. Kicked out of our home because of greed. This city used to be filled with freaks and weirdos. Now look at it."

"Except the freaks haven't always been here," Eddie said. "Think of the Castro in the seventies. That used to be an old-school working-class Irish neighborhood. Then the homosexuals moved in and— What?"

Jessica's mouth was hanging open.

Eddie turned instantly pale. "Shit. Is that wrong? Am I not allowed to use that word that anymore?"

"Just say gay," Jessica said.

"Isn't it LGBT?" I said.

"Actually," Jessica said, "I think it's LGBTQ now."

"Doesn't the Q sort of sum up the rest?"

"Spoken like a straight white man."

"You don't know that I'm straight."

"Ha!" Jessica barked. Spitting several pieces of rice across the table.

"My *point* is," Eddie said, "when the gay community came in, do you think all those old-timers liked it? Seeing what they thought of as freaks taking over their neighborhood?"

"Yeah," Jessica said, "but they were all homophobic conservatives, so who cares."

"But what if we are too?" Eddie said. "No, really. Think about it. What if we're the equivalent? What if history will look back on us as techie-phobic conventionalists, and we don't even know it?"

Jessica stopped chewing. She turned to Eddie to yell at him again, which was clearly her default response to most of his ideas, but as his point sunk in, she lost all her steam. "Maybe," she said. "But that just makes me like your earthquake idea even more."

5

SOMEONE NUDGED ME and I woke up. I had said good-bye to Eddie and Jessica and just started walking. Now I was standing in line at a café. I couldn't say how long I'd been there, and didn't even remember coming in. But there was a big gap between me and the counter, so I moved forward.

"You alright?" Justin asked. I was glad someone I knew was working. Instead of waiting for an answer he handed me a mug of coffee.

I thanked him and moved off to the side.

Hot coffee is always too hot for me so I did my usual and poured in a little ice water. As I took a sip I looked around for a seat. One was just opening up at a long shared table, a prime spot against the wall, so I walked over and hovered while the guy packed up. When he saw me I could swear he slowed down, like people do when they see you waiting to pull into their parking space, because suddenly he remembered that he needed to set his bag back down and rifle through it

and not pull anything out. When he was finally done
he smiled at me in a way that told me I wasn't just
being cynical, and so I made no effort to get out of his
way, making him squeeze past. Careful, I said to myself.
It's becoming one of those kinds of days.

I sat and turned so that my back was against the wall.
The metaphor was too on the nose, though, so I decided
to leave it alone.

Something was off. I rubbed my eyes and drank some
more coffee. Suddenly I was on the floor and people
were helping me up. "Are you alright?" This was the
second time I'd heard that in two minutes. I wasn't so
sure. But I said I was, and after thanking them I settled
back into my seat. I didn't know what was happening.
The world had slid to one side, like a camera on
a faulty tripod.

"Hey, you're the All About Coffee guy," the man next to
me said. He hadn't been one to help me up.

"Over," I said. "All *Over* Coffee."

He didn't hear me. He turned to the woman beside him
and said, "He does those coffee paintings in the paper."

"They're not—" but I gave that up, too. "I also write stories."

"Right," the woman said. "You're being evicted." Then her face disappeared.

"Whoa!" the man exclaimed. And next thing I knew his hand was on my shoulder and the world was sliding around again. "Careful there buddy, you almost went down again."

Something was seriously wrong. And it wasn't just that the camera kept falling over—well, okay, yeah, that was bad—but there was something else. About a third of the people in the café, they no longer had faces. Or, I supposed they did, but to me they were blurred out.

"Your work has become very polarizing," the woman spat at me. "Housing is a complicated issue, and gurgle, blasafell dsakl qsalk;'-&./"

"I know," I stammered, unsure how this woman could know what I'd only just learned a few hours ago. "But I'm using absurdity to show how—"

But the woman just shook her head then turned to the guy and rattled off more gibberish.

"I don't know," he said to her, "I can understand him fine."

I took a deep breath and did my best to articulate my point of view, but even to my own ears the words sounded stilted. I was trying to say that a part of me felt responsible for this happening. That being evicted carried a weird shame. That the city was being divided into two camps: those who could afford to buy a home, and those who couldn't. I was trying to say that it felt like a new class system. One where it didn't matter how successful you were at your profession, because if you were unable to buy a home, then the implication was that you weren't successful enough.

The guy smiled tightly. He put a hand to his heart. "I hear you," he said. "You're an artist—"

"And a writer," I said. But for some reason he was still unable to hear that part.

"—And you're able to make a living in San Francisco? That's amazing."

"Right—"

"But—" he pointed with his thumb to his friend "—her family has owned real estate here for generations."

To which the woman responded by waving her hand through me, as if I were a ghost.

6

THAT EVENING I showed up to an open house ten minutes
early to find the place already packed. Which would have
been frustrating had I not already known it wasn't for me.
It was twice what I could afford, half the space I needed,
and way too centrally located to ever go to someone
over thirty.

When I turned to leave I did a double take. Across the
room was Jessica, who I'd had burritos with earlier that
day. Instead of pretending to be pregnant, she was now
dressed in a full burka. I could only see her eyes, but I'd
know those dark, rifle-barrel orbs anywhere, firing signals
that said if I gave her away the only place I'd ever have
to worry about finding to live again would be an urn. She
was standing demurely beside a tea-colored man—who
I suddenly realized was her boyfriend Eddie, also in
disguise—as he talked with a short man wearing a skullcap.

I decided to stick around to see what happened, and
when they were done, as Eddie drifted to the corner on
his phone, I sidled up next to Jessica. "Hey," I whispered,
"I like the costume."

"What are you doing?" she spat. "Get away from me. You think the woman I'm supposed to be would be caught dead talking to you alone?"

Ignoring her I said, "I'm guessing you think the landlord is Muslim? But I'm pretty sure the guy you were talking to isn't the owner. That's the owner over there—" I pointed to a tall, blond guy with a man bun. "His name is Jake and his accent is even more Texan than his oil derrick tattoo."

Just then Eddie came over. "Shit," he said. He was wearing skin toner and a fake moustache, which he peeled off to reveal a band of light skin, as if he'd fallen asleep in the sun and gotten burned before shaving. "We got the wrong info about the owner again."

"Dammit Eddie!" Jessica said under her breath, but just as she grabbed him by the shirt the fire alarm went off and everyone ran for the door. When we were safe outside Jessica tore off her headscarf and began yelling at Eddie for screwing up the landlord's info—*again*—only to be interrupted by the man in the skullcap they'd been talking to earlier. "I can appreciate your effort," he said. "And I would have

rented you the place on your moxie alone. Had I not sold it this morning to a nice young man from Texas."

Eddie gave Jessica a smug, 'See-I-wasn't-wrong-about-the-owner-after-all' grin, to which Jessica just shook her head. Then something in her changed. She looked around at all the people and began counting heads. "Crap!" she yelled, then turned and sprinted back into the building.

Eddie and I followed her up the stairs and back into the unit to find the Texan with the man bun shaking hands with a curly-haired woman in a firefighter's uniform.

"I admire your American ingenuity," he said to her. Then he handed her a set of keys. "The place is yours."

7

"IT'S SO COLD," a blond, pear-shaped girl said. She was
dressed in a black tank top and yoga pants stretched
so tight I could see clear through to her panties—white,
patterned with little red skulls.

It was five in the morning, and the first hint of daylight
was blooming on the horizon. I'd been there since ten
the night before, in response to an ad for a two-bedroom,
and was, from what I could estimate, eighty-third in line.

The guy in front of me had set up a pup tent, which
I was jealous of, not just because he'd had the fore-
thought to make his wait comfortable, but because
around midnight he'd sold it for nine-hundred thousand
to a twelve-year-old in a snow hat.

"Listen," he told the kid, "you know you're just going to
have to take this thing down in a day?" To which the
kid shrugged and said, "It's still a great deal. By then
I'll have sold my company."

"Oh?" the pup tent guy said. "What's your product?"

"It's called Complicapp. An app that creates unnecessary steps in already functioning systems so that developers can justify making new apps."

Except the pup tent guy wasn't listening. He'd run the kid's credit card and was already moving on.

I laughed at the absurdity of it all, and the pear-shaped girl behind me scoffed. I turned to see her sneering into her phone. "Just this idiot in front of me," she was saying. "When are people going to learn that history hates haters?"

Now it was dawn and the girl was complaining that someone should design an app to stop San Francisco summers from being so cold, and that's when the pup tent guy came back. He walked up to the unzipped flap and began counting out a stack of hundreds to the snow hat kid. "I emailed about renting the place," he said, and the hat nodded. Then the kid left and the guy climbed back into the tent he'd sold only a few hours earlier.

"Oh great," the girl behind me said. "*Now* look. The fog is blowing in." And I turned to see a dark mass moving across the sky.

"That's not fog," someone called out. And sure enough, as it got closer, we could see the cloud wasn't the chilly mist San Francisco was famous for, but a swarm of digital code. It fell upon the crowd and someone screamed, "It's a rush of investment capital from China!" Another voice cried out, "No, it's Canadian!" And suddenly everyone's clothes began disintegrating, as if we hadn't been wearing actual fabric but body paint that was now washing off in the rain. Completely naked, people began running in all directions.

"Sweet," I said. "Now I can move to the head of the line."

"Line?" the pup tent guy said. "Did you think you were here waiting to see an apartment?" And before I could reply he pulled out a sharpie and drew an outline around my bare feet. "This spot here," he said, holding out his hand. "A thousand bucks-a-second."

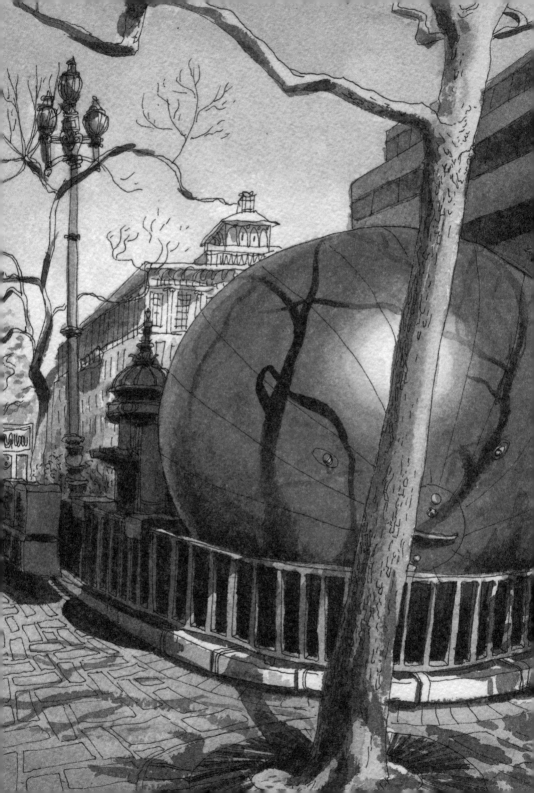

8

I DECIDED TO TRY Oakland. There was a bungalow
I was willing to consider listed for 950k—which
seemed like an unfathomably large amount of money,
especially for having to leave the city, but I needed
to feel I was exploring all my options.

I rode BART under the bay and when I got to the
address I stood out front with mixed emotions. I was
relieved to see that of all the houses on the block it
wasn't the burned-out shack or the rotting box of
peeling paint, yet at the same time, was depressed
to know that despite it being a nice enough looking
little home, this was, in the end, all I would get for
a million dollars—and that was if I could even come
up with a million dollars. Anyway, I thought, at least
it has a driveway.

Still, I didn't go in. I stayed on the sidewalk. As with
every other listing I'd seen, hungry buyers were
swarming the place, probing every crevice, acting as
if they already owned it while everyone else was just
a squatter begging to be shot.

"Why you even want to live in this neighborhood?"
a deep, melodic voice said. I turned to see an older,
African American man with a trim grey beard sidling
up next to me. He appeared to be in his late sixties and
wore a freshly pressed pink button-down shirt tucked
into a pair of crisply creased grey suit pants. He and
I were just standing there on the sidewalk, side by
side, arms crossed, watching the scene, when someone
spotted him from the porch and yelled, "Look out!
I think he has a gun!" At which the man snorted. "You
can leave your hoodie at home," he said, "but people
still want to fight."

"I'm just trying to find a place to live."

"Being pushed out of the city, huh?"

I said yes while we watched a beefy guy with a baby
strapped to his chest 'accidentally' staple his credit
report to the real estate agent's forehead.

"What gets me," the man said, "is how you city folk
complain about entitled techies forcing you out, only to
come over here thinking you have every right to move
on in."

I turned to look at him. He continued looking at the house. He was right of course, but these weren't easy subjects to broach—economics, race. I was a middle-class white guy. Pretty much anything I had to say would be wrong.

Just then a helicopter flew overhead. One of those service birds that the Forest Service uses to drop water on fires, trailing what looked like an enormous boulder underneath. I was trying to understand how a chopper could manage to lift something that big, let alone stay aloft carrying such a load, when suddenly the boulder dropped.

We barely had time to blink before it hit. The wave rippled through the ground as if someone had tossed a cinder block into a still pond. It lifted the man and me and carried us further inland, toward those last stops on the BART line that you see on the map but never visit. I'd fallen on my butt and was struggling not to be thrown completely off, but the man was standing still, leaning forward with a hand cupped above his eyes, holding steady, like a sea captain heading into a familiar storm.

9

I REALIZED THAT I had not been home in two days. At least not inside. Not since I'd found the eviction notice on my door. Seeing that had made me panic. I'd immediately rushed off to secure a new place to live, only to discover just how cutthroat the housing market really was. Now I felt beaten and in need of rest.

Back home I found my front door plastered with nine more eviction notices. Did my landlord think I couldn't read? A bicycle tour group pulled up in front of my building. A dozen or so people, all on rental bikes with fanny packs strapped to the handlebars. The leader pointed to my door and raised a megaphone. "This is number 54 on this week's no-fault eviction tour," he announced, pausing to chuckle. "But of course it will be available at market rate in no time."

Inside, the flat felt different. I was suddenly hyper-aware of all my things. Of how I would have to touch every object, then decide what to keep and what to toss. The thought was overwhelming. Because the truth was, I owned way too much. Ten years had

turned my place into a stuff hotel; items checked in, but they didn't check out.

I went into the bedroom. It was afternoon, and warm sunlight oozed through the southern window. I collapsed onto the bed and stared out at the view that would be mine no more. A silly thing to be sentimental about. It wasn't like the view was going to miss looking in at me.

I was surprised by how hard I was taking this. Yes the flat was charming, but it was far from perfect. The windows were drafty, the electrical outlets were both two-pronged and too few, and the heater was a clanking joke that scorched everything within a two-foot radius while warming the rest of the flat as much as a dog's fart in a walk-in freezer. I called the place home, but was it? I mean, really? After a decade, living here had become more habit than choice. I could probably walk every inch of the place in complete darkness without bumping into one wall or piece of furniture, but was that the meaning of home? How much had my routine behavior created a routine of thought? Maybe I was stuck in a rut here and didn't know it. Maybe this eviction was just what I needed. Wow, I thought. Look at me. Mister Lemonade.

This interlude of optimism must have just been me dozing, though, the result of my mind hovering in that place where you think you're conscious but where you're actually asleep, because a sudden pounding jolted me awake. I looked around and saw the bike tour group on the roof next door. One of the guys was trying to plant a flag. Over and over he stabbed at the roof until finally the pole broke through and stuck.

The fabric was white and the wind was whipping and I couldn't make out any emblem so I thought the flag might be blank. Which would have been pretty cool. But then I realized there *was* an emblem, except something was preventing me from seeing it. A sort of blurred-out-ness, like when the local news shows footage of nudity. Suddenly a face popped up and pressed its nose against my window and I let out a little yelp. It was one of the bikers. She held up her phone and pointed to the screen. "To continue," she said, "you'll need to give us your email and click this box. It's our terms and conditions."

10

THE WAITING ROOM of the Tenants Union was packed like a New Delhi train station. It also turned out to be the same room where the civic-minded lawyers who volunteered to counsel renters on their rights held court, so I sat down, and for the next three hours listened to the parade of locals ahead of me voicing their housing grievances.

There was the retired Colombian woman who complained for twenty minutes about her programmer housemate replacing her statue of Ganesh with an *X-Files* poster. "It's this huge picture of a bug-eyed alien," she said, her voice getting louder and more high-pitched with each word. "And underneath, where it says I WANT TO BELIEVE? He wrote, IN SOCIAL MEDIA!"

Then there was the stocky Irishman in flip-flops who, even though he'd just sat through hours of listening to other people's babbling, thought he should spend a few minutes making small talk before launching into his problem. "So ya moost be all kindsa bizzy these days, eh? What with all the evictshuns and sooch?"

And then there was the young Chinese woman in designer shoes whose parents were footing the bill for her $6,000-a-month studio apartment, who casually fondled the top button of her blouse as she went over her ten-page lease, line by line, asking questions like, "And so, when it says I have to pay a security deposit, what assurance do I get that the *landlord* is secure?"

When finally it was my turn the lawyer took one look at me and sighed like a high school principal who only just that moment accepted the fact that he would never be the next great American author. But having waited patiently, I took a breath, smiled as congenially as I could, and explained that my landlord was, in my opinion, abusing a legal loophole in order to evict me. The lawyer dropped his head into his hand and listened with the eyes of an old hound dog waiting to die, and when I was done, said, "So don't move."

"Wow," I said, with what I realized was the first tinge of hope I'd felt in days. "So then she can't legally evict me?"

"Well—" suddenly he was wide awake and holding up his hands in defense "—I don't want to say anything that I can be held accountable for. But, legally? Yes.

Absolutely she can evict you. And if you don't go, she can get the sheriff to throw you out."

"Okay…" I said, confused. "So then what is it you're suggesting I do?"

The lawyer shook his head at me as if we were in a locker room and I'd offended his manhood. "I just told you. Don't leave." Then he demanded I pay a donation and called the next person in line.

11

I HIT THE STREET angry. I didn't want to be, but the more I tried to let it go, the angrier I became. A guy was passed out on the sidewalk. As I walked around him, I looked at his shoeless, rotting feet and the can of beer in his hand and tried to tell myself that life is full of problems, and that what matters most is not the injustice we feel, but how we comport ourselves in the face of it. That as much as I wanted to blame the city for my situation, if I couldn't muster anything more than bitterness, then I was complicit in making it worse. Then a motorcycle gunned its engine and the string of car alarms it set off blew the thought out of my head.

I took a breath and tried again. At the corner a car was stopped at the stop sign so I paused to let it pass, but when I stepped off the curb to take my turn the car behind it ran the sign and I had to jump back to keep from being hit. I threw up my hands and yelled and the car slammed on its brakes. It was a dusty black Prius. The window rolled down and a tattooed arm shot out and flipped me off. Then it just sat there, in the middle of the intersection, waiting for a fight.

I took another breath, shook my head, and walked
away. I wasn't going to have a punching match in the
street, but at the same time, I was sick of it all. As
I stepped over a fresh pile of dog shit, I thought: Screw
this place. And everyone in it. Maybe it's time to leave,
find someplace new. Just then a band burst out of
a storefront. A bearded white guy pumped an accordion
while a lanky black man blew a saxophone. A young
Latina jammed on an acoustic guitar and began to
sing. Her voice poured over me like warm bathwater
and suddenly the world was right again. I slid in with
the crowd and began to lose myself in the music until
a donation hat was shoved into my chest and a mouth
with a face wrapped around it barked, "If you're not
for us you're against us!" and I fell backwards into the
street, where a bicyclist flew by and screamed that
I was endangering his life. Stumbling, I ran to the other
side of the intersection and joined a group of people
standing still, staring at their phones, even though the
light was green.

Fuming, I crossed the street and took refuge against
a building. I looked up Twenty-Second Street. The
weather was sunny and clear, and Twin Peaks glowed
golden in the autumn light. A warm feeling rolled over
me as I was reminded how gorgeous this city could be,

and I thought, You don't need to leave. You just need to stop playing the self-righteous role of Only Sane Man and focus on what's important. But then I felt another warm sensation and looked down to see liquid splashing onto my ankles. A guy next to me was pissing onto the building, his face inches from a sign that read: BEWARE! PEE REPELLING PAINT, which he clearly was not comprehending, given that the building was doing just as advertised, shooting his stream right back onto him—and me—with the force of a fire hose.

I jumped away and bumped into a guy wearing a backwards-facing baseball cap who shoved me off him and into another guy who said, "Whoa there, Bra," as he caught me. He was a smiling, curly-haired kid with an enormous set of headphones around his neck, a designer laptop bag across his shoulder, and ratty flip-flops on his yellow-nailed feet. "Careful," he said. "It's like a videogame around here." "No," I cried back. "It's not. The only thing like a videogame is a videogame. This is the real world where we live." But he was already gone, strolling down the sidewalk, puffing on an electronic hash pipe.

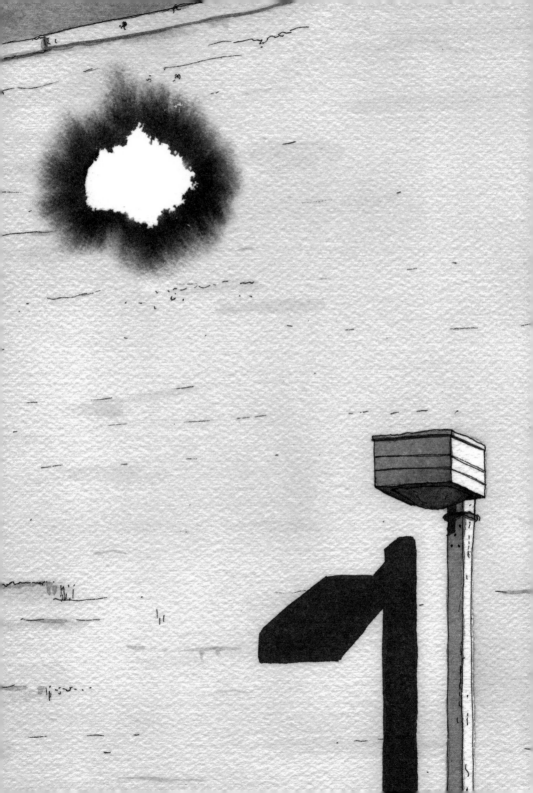

12

I WAS INVITED to do a commissioned work at the office
of a startup at Sixth and Mission. The company's name
was Picassew. "We specialize in helping artists," the
young woman who greeted me at the door said. She
introduced herself as the Chief Resources Executive
Marketing Assistant. This was after I had to be buzzed
in from the street, texted a code for the elevator, then
let in through a triple-bolted door.

"We've just raised three million dollars to launch our
app," said the young woman whose job title acronym
I realized was CREMA. "We promote artists' work by
*sew*ing it into the community." Then she looked at
me with her mouth hanging open. "Get it?" she asked.
"Picass-*sew*. Like Picasso and—"

"I get it," I said.

She led me into their office, a large open space with
high ceilings and exposed pipes. Three rows of tables
stood in the center where ten or so people sat in front
of large monitors. The office was on the corner and

had tall windows lining two of its walls. I guessed they would have let in great light, but it was hard to know since a construction crew was busy covering them over with plywood.

"These panels are where your art will be," CREMA said. "They'll be attached to light boxes to give the effect of natural daylight."

"So you want me to cover over your view with drawings of another view?"

"Not another view," she said. "The same view. But, you know, better."

A high-pitched alarm went off. Panic crossed CREMA's face but she quickly regained composure and excused herself. She went to the row of tables, reached over the shoulder of a thin young man, and pressed a button on his keyboard. A video popped on-screen of what looked to be a live feed from the security camera pointed at the building's entrance.

"I think it's just the delivery guy," the young man said, but buried in his voice was a worried tone that implied, "or someone who wants to hurt us."

"Zoom in," CREMA said, and as she studied the man on-screen she bit her lip. He wore a baseball cap and carried a large padded box, both of which had the same delivery service logo. He reached out and pressed the door buzzer, and again the alarm sounded in the office. The Chief pulled out her phone and dialed.

"Hiii," she said in a sickeningly upbeat voice. "Yeahhh. We placed an order for delivery? And I just wanted to confirm that your delivery person is—yeah!" A burst of fake silly laugher. "That's him alright! Thank you so, so, *sooo*, much." Then she hung up and told the guy at the computer to buzz him in.

She hurried past me and waited at the office door until we could all hear the ding of the elevator, then she undid the three deadbolts, flung open the door, and bounced on her toes like a lonely suburban housewife pretending to have been caught in the bath when the pizza man arrives.

"Sorry 'bout that," she said to me after handing off the food to the guy at the table. "It's *really* important to us that we support local businesses. Once a month we even go out and walk to a nearby restaurant. I mean, you have to go that extra mile to be part of the community, you know?"

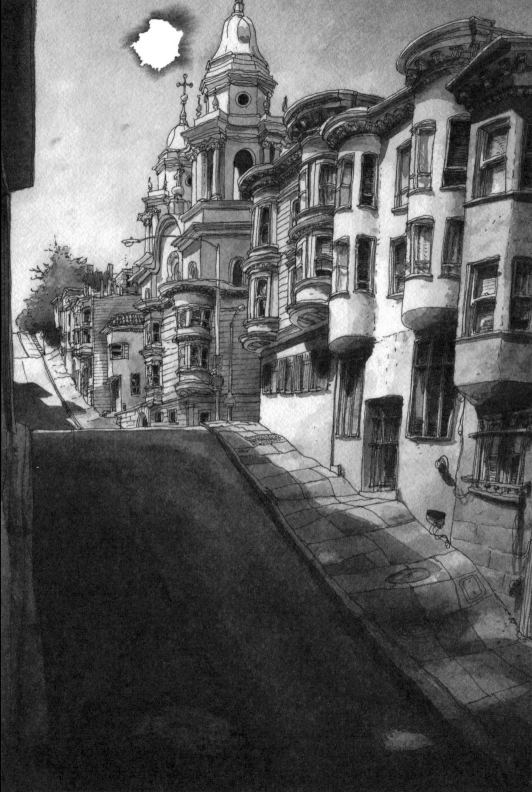

13

IT WAS MY BIRTHDAY and I went to North Beach.
I just wanted to forget how angry I was that the city
was changing faster than I could keep up, to draw
something nice, and take myself out to a dinner of
spaghetti and wine.

I wandered until I found a spot just off the beaten path
where the light and composition grabbed me. I set my
bag between my legs, took out my pad of paper, and
breathed in deep. For a few minutes I just stood there,
letting the scene calm me. The angles of the buildings,
the reflections in the windows, the drapes of shadow
spilling over the forms like a viscous film. These were
my tonic. And once they were flowing through me,
I began to draw.

The street was mostly empty, and as my lines took
shape on the page, an occasional person walked by.
Then a man appeared. He came straight toward me.
I thought he might be a curious local, or even a fan,
but then I recognized him, and for a moment I couldn't
breathe. The man was me. I was looking at myself.

I rubbed my eyes. Ever since receiving the eviction notice, life had become darkly absurd. I'd had bouts of dizzy spells. People's faces had disappeared. Clouds of computer code had stripped people bare in the streets. There were nights when I'd lie in bed and wonder whether I was falling asleep or waking up. And now here I was, looking at myself, standing right in front of me.

"I remember that one," this other me said. And when I didn't respond he arched his brows and pointed to the pad of paper in my hand. "It turns out to be a pretty good drawing."

He even sounded like me. And his face, it was like looking in a mirror, except the reflection was trimmer and had a better haircut, which made me hope he really was my future self—I mean, no matter what else happened, if I had only those changes to look forward to, then I'd be happy. Still, I didn't understand how—

"You're not crazy," he said, clearly reading my thoughts.

"Okay."

"But you do need to stop this sniveling."

And instantly I understood how some people could find me annoying.

"For all that you observe," he said, "you don't see what's right in front of you." He pointed into the distance and I followed his finger to see a strange cloud hovering in the sky. It looked like a burn mark. "That's been following you for months," he said. "And it's going to consume you."

I opened my mouth but he cut me off. "Listen," he said. "It's all going to happen really fast now."

"The eviction?"

"The—? Oh right. No—well, yes. You're going to lose your place. But in the end, that won't matter."

"The end?"

He smiled tightly and I recognized the heavy look in his eyes. It was real compassion. Not the distorted mix of sympathy, pity, and unease I often feel in the face of hardship, but genuine empathy. Which I supposed made sense—I mean, if we can't muster real feeling for ourselves, who are we ever going to come alive for?

"Forget about the move," he said. "You'll get a new place. Yes, it will be hard. Your landlord will be ridiculous. She will literally put her fingers in her ears and shout, 'La la la I can't hear you.' A sixty-year-old woman who you believe intentionally abused the law to screw you will act like a child. It will be infuriating. But you will remain in the city, and in some ways, life will be better. Your neighborhood won't be great, but it will offer a new perspective. You'll have a big work space, good amenities, even a garage. You'll sort through all your things, and it will suck. You'll throw out truckloads, some of which you'll later wish you'd kept, but you'll justify by saying, 'At least I know I didn't throw out too little.' Your expenses will triple, but you'll find you can afford it. Your work will change, but you'll know that was coming anyway. You won't be thankful for the experience, but because you won't let yourself be a person who wallows in victimhood, you will gain an even deeper appreciation for life being short and tell yourself: 'I'm a better person for it.' You'll tell yourself: 'The city changes, and either I change with it, or I get left behind.' So let go of all your anger, your fear. Forget all your petty criticisms and revenge fantasies—which you know you have. Take yourself to your birthday dinner and enjoy your spaghetti and try to be happy with all the good things

that you *haven't* lost. Because that's all there is. Even with what's coming next."

But before I could ask what he meant by 'next,' a screech of tires spun both our heads. I saw an orange VW van speeding our way and suddenly it was right there, door sliding open. Two figures jumped out and there was only blackness as a hood was thrown over my head. Up was down then I slammed onto a hard surface. I heard a voice yell, "Go! Go! Go!" and felt the van rocket off.

14

I WOKE UP to darkness and a headache. The air smelled heavily of incense and patchouli, and I could hear a man and a woman having a heated conversation.

I was lying on my side, but when I tried to sit up I discovered that my hands were bound behind my back and my feet were tied together.

"He's awake," I heard the woman say, and in a flash the cover was pulled from my head.

I winced at the sudden light. The man bent down and put his face close to mine. He had long, scraggly hair and wore a candy necklace with most of the pieces chewed off. His jowls were leathery, with deep creases that told of hard years.

"The techies think you're old," he said. "And the rich think you're common. Activists think you're bourgeois, and the bourgeois think you're just another weird artist." He said all of this with no emotion, adding, "Who do *you* think you are?"

I looked around. I was more concerned with *where*
I was. The room was small and Victorian. There was
one bay but the windows were covered with batik-dyed
sheets. The walls were awash with psychedelic posters
and political slogans, and the mantle was caked with
years of colored candle wax.

"Your series," Jowls said. "All Over Coffee. It's a mess,
you know that? You used to be contemplative. Timeless.
Now you're doing satire, commentary, meta-fiction.
You're all over the place."

"Maybe I should rename it," I said.

He smiled. "All Over the Place. That's funny." He seemed
genuinely amused. "Too bad your work doesn't have the
same sense of humor."

"I thought it did."

"No," the woman standing behind him said. She had
long, straight grey hair, and a black turtleneck that
had clearly never known joy. "You're much funnier in
person." And suddenly I realized that this was Jessica,
the woman I had met apartment hunting. It was her
eyes. Those rifle-barrel orbs. But something about her

was different, and then I understood. This time she wasn't in disguise. This was the real her.

I looked around for Eddie, who I'd known to have a cooler head, but Jowls grabbed my face. "Listen," he said. "We know you're not the enemy. And I'm sorry we had to tie you up. But *man*, you need to get your message straight." His spastic eyes implored me. "This city… It used to be a haven. But now I can't even step onto my bathroom scale without it reporting my weight to some database. My refrigerator wants to keep tabs on how many times I open it. That's not the product of dreams, man, that's surveillance. Control. Nerdification. The geeks have taken over. They're complicapping everything, and there's no heart left anymore. Emotion has become *e*-motion. Electronic everything."

"I get it," I said. "But I'm not actually anti-tech. I use technology all the time." I had no idea why I was arguing. I was angry too. I felt I was being cheated and had no recourse. And yet, I couldn't bring myself to agree with anyone who advocated violence as a defensible solution to injustice.

I had Jowls' attention, though. He was listening. Intently.

"And really," I said, "I think a lot of the people flocking here, they're forward thinkers. Problem solvers and entrepreneurs. Which is exactly how I think of myself. It's just—" I tried to raise my hands to qualify my statement, but because they were tied, I had to resort to arching my brows as expressively as I could "—tech is like every other profession. You have a handful of talented visionaries, and the rest are incompetent opportunists following the herd. Granted, their generation is a bit too group-oriented for my taste, and a bit too afraid of sitting alone in a room for more than three seconds, but they *do* like to work at cafés, so I mean, come on, how can you complain about that? My entire life is based on drinking coffee." And I tried to lighten the mood with a laugh, only it was a little too forced. "Look," I said, getting serious again, "I think the real issue here isn't so much tech as it is the age-old problem of greed. Of entitlement and influence run amok."

"Yes!" Jowls cried. He squeezed the air and shook his fists. "Which is why this wave is so toxic. It's *because* they believe they're in the right that they're so dangerous! Which is exactly why we need to do something about it! Man, when a city is so overrun that you can't find a place to live, what's the point of

living there? *Culture?* What exactly *is* the culture here these days? This place used to be beautiful, man. The Bay Area. But how do you separate a place from its people?"

Just then two cronies rolled a large object into the room. Something between a jet engine and a giant lava lamp with exposed wires and a countdown timer. My heart froze in my chest. Until this I had been weirded out, but not so much afraid. But now—well, I paid attention to the news. The world was infested with zealots. Used to be we feared religious and political terrorism, but now it was a state of mind, the nature of radicalization. The question was no longer what cause a person might be fighting for, but how that person might fall prey to extremism, regardless the ideological root. And here I was, witnessing the answer first hand.

"Just one earthquake," Leather Jowls said—and that's when I saw through the leathery skin and realized that *he* was Eddie. The once baby-faced and thoughtful young man was now a haggard and militant old fanatic. "That's all we need for these newcomers to know what it's *really* like here. One quake to scare off the next wave of foreign investment and cool

down the real estate market." Then he grinned and shook a finger at me. "And we have you to thank for the idea."

"What?!"

"The burns," Jessica said.

"The—?" Then I understood. My drawings of burns eating through the images. "No," I said. "The quake—Eddie, that was your idea, in the taqueria. Remember?"

But that Eddie was gone. In his place was only the madness that had consumed him.

"The burns," I stammered. "Those were just—" But then I remembered. The burns had been a prophecy, shown to me by my future self. And before I could say any more, the hood was thrust over my head again.

A sharp, bitter smell stabbed my nose and the last thing I heard before the world went dark was Jowls—Eddie—saying, "It's history, man. San Francisco has been burning itself down—literally and figuratively—for years. From the Spaniards and the Indians to

the Irish and the Italians, from the Gold Rush to the Summer of Love. And this time, it's ol' Mother Nature who's come to scorch the earth."

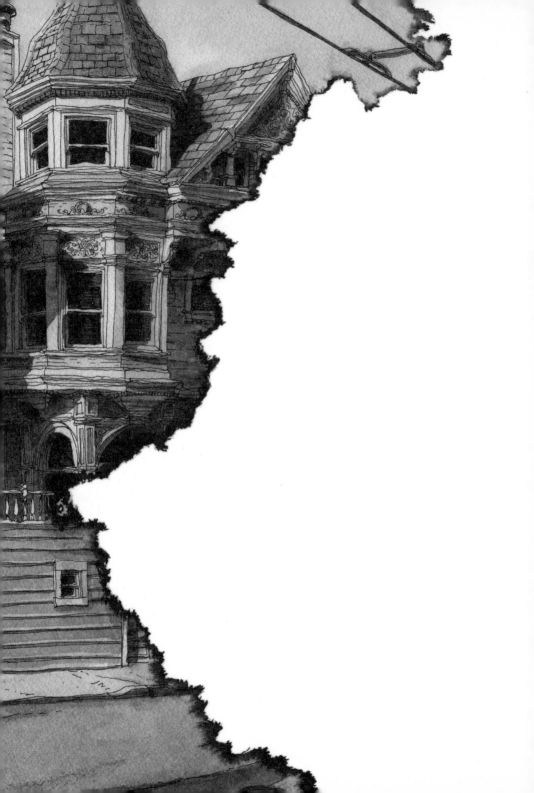

15

I WOKE UP on the sidewalk out front of a vegan donut shop. Overhead, loudspeakers were broadcasting holiday music. How long had I been lying there? Had no one noticed? Or thought to help? Then I saw that the block was lined with homeless tents and shopping carts and knew these were foolish questions.

In a flash I remembered the last episode, with the giant lava lamp earthquake device, and I quickly pulled out my phone and dialed the newspaper that published my work. As the line rang I found myself debating whether or not it was a good idea to claim that Rebel Hippies had kidnapped me and confessed their plan to 'shake things up.' Would anyone believe me? Did *I* believe me? When the line was answered I asked for my editor. "She no longer works here," an unfamiliar voice said. I started to ask why but decided instead to give my account of how I'd found myself in the unwanted role of Messenger of Protest.

"Does this involve celebrities who want to be president?" the guy asked with an exasperated sigh, and when

I told him no he replied, "Okay… Well, was there a cat in the room? Because if there was a cat, then we could definitely use that."

I hung up. A woman came out of the donut shop and for a moment the holiday music got louder. It was like an explosion inside my head. I grabbed my ears and doubled over. I wondered if while being held hostage I'd been barraged with Christmas songs as a form of torture. Then I realized that no, that had just been regular everyday life since Halloween.

I grabbed a cab back to my flat. It was only eight blocks but I didn't have it in me to walk. The cabbie got lost three times, and when finally we arrived he demanded a fat tip. I began to protest and he yelled, "This isn't Uber!"

I managed to jump out as his tires squealed and he fishtailed into traffic, only to find my front door plastered with so many eviction notices that the handle was a barely visible mound beneath the paper. I took out my keys and used one to slice through.

Upstairs I looked at the boxes of all my packed things. The flat seemed small and foreign, and in it I felt like

a caged animal. I began pacing until all I could do was scream. As loud as I could, I screamed like I'd never screamed before. Then I screamed again. And when I was done, all I wanted was to curl up in the silence and hermetically seal myself off. But that was impossible. My home was mine no more, and that's when I saw, outside the window, the burn was coming in fast. It looked like an inverted storm cloud, consuming everything in its path.

Whether I liked it or not, this era of my life was now at an end. I thought back on All Over Coffee, of the last twelve years of my work, and while in my bones I knew I'd given my all, there was still more to say. For example, I wanted to talk about how each of us has our own version of San Francisco. A portrait that is formed on the day we arrive, and that, as the years go by, we hold up as the one true representation of the city. But because it's a portrait of our own making, it's different from everyone else's, and therefore, inherently false. Which is why I know that what I'm about to say is surely just another distortion, that maybe the only true nature of San Francisco is one of change. A boomtown. Where dreams are tested and lives are remade. Which is the very reason why so many of us love it here. And why to complain about

it changing is like going to a heavy metal concert and bitching about the music being loud.

I shook my head to myself. It was a clever, but one-dimensional idea. Because there was another side, a counter argument that said that not all change can or should be tolerated. Which I instantly recognized as true. The issue then was about drawing lines. Between progress and stability. Between tolerance and rules. Clearly I was still sorting out these lines—as we all were. But it didn't matter. Time was up. Beyond my window, the buildings were gone. In their place was surely something new, but all I could see was a blinding white of nothingness. And so, with only a few minutes left, what did I really want to say? Did I want to go out on a snark? A burst of showmanship? A loving farewell? All three would have been nice. Except now the burn was at the window, consuming the edges as if they were a lit fuse.

So I decided just to say thank you. I had been twenty-one when I'd come to San Francisco to make my name, and now I was forty-three. I'd had the opportunity to wander the streets, draw corners of buildings, and scribble odd quips that readers took for overheard conversations. I'd expressed my vision of San Francisco,

and was lucky enough to have others appreciate it.
I had succeeded. My dream, along with my version of
this city, had been fulfilled. But now the walls were
completely gone, and the edges of the floor were
being eaten away. Only a small island of hardwood
planks remained beneath my feet. As I watched them
disintegrate I felt surprisingly calm. Exhausted, for
sure, but in truth, also a bit relieved. Because as this
last piece fell away, I knew. This wasn't just my story,
but the story of every person who has ever wanted their
version of their world to stay the same. It was time to
let go. Time to move on.

On to the next dream.

ABOUT THE AUTHOR

Paul Madonna is the creator of the series **All Over Coffee**
(*San Francisco Chronicle* 2004–15), and the author of two books,
All Over Coffee (City Lights 2007), and *Everything is its own
reward* (City Lights 2011, winner of the 2011 NCBR Recognition
Award for Best Book). His drawings and stories have appeared in
numerous international books and journals, as well as galleries
and museums, including the San Francisco Contemporary Jewish
Museum and the Oakland Museum of California. He is the former
Comics Editor for TheRumpus.net (2009–16), has taught drawing at
the University of San Francisco, and frequently lectures on creative
practice, even when not asked. He holds a BFA from Carnegie
Mellon University, and was the first (ever!) Art Intern at *MAD
Magazine* (1993–94), for which he proudly received no money.

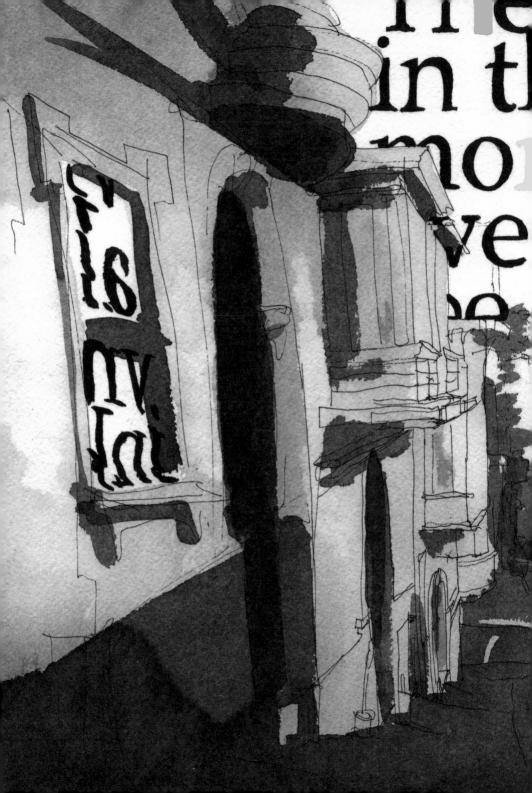